Christian Adult Coloring Pages
30 Love Bible Verses To Meditate and Color in
By: KamKel Press

Copyright 2019

This Book Belongs To:

Introduction

This Inspirational Coloring book with love Bible Verses was created to help you understand the Father's love for you. Jesus' love is forever true because He first loved us. No matter what you may be going through, please understand that He is ALWAYS with you.

I hope you find hope, peace, joy, contentment and love as you meditate and color in these pages.

Grace Be with
All Those Who
Love Our Lord
Jesus with
Incorruptible
Love.

- Ephesians 6:24

BUT IF ANYONE LOVES GOD, HE IS KNOWN BY HIM.

- 1 CORINTHIANS 8:3

GREATER LOVE HAS NO ONE THAN

THIS, THAT ONE LAY DOWN HIS LIFE

FOR HIS FRIENDS. - JOHN 15:13

FOR THE LORD IS RIGHTEOUS, HE LOVES RIGHTEOUSNESS;

- PSALMS 11:7

Those Who Love Your Law Have Great Peace, And Nothing Causes Them To Stumble

- Psalms 119:165

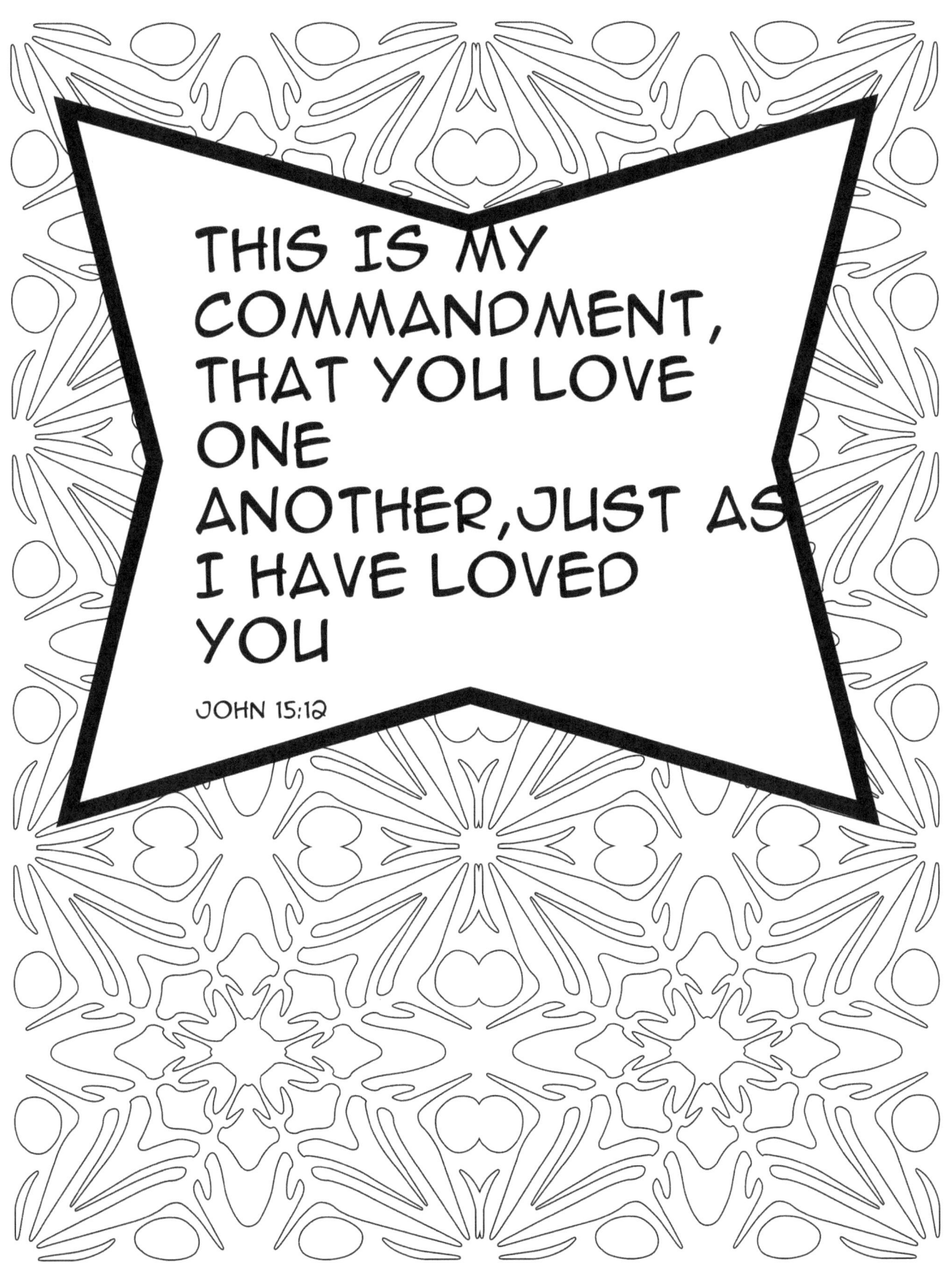

But God, Being Rich In Mercy, Because of His Great Love with Which He Loved Us.

- Ephesians 2:4

BELOVED, IF GOD SO LOVED US, WE ALSO OUGHT TO LOVE ONE ANOTHER.

- 1 JOHN 4:11

Love Is Patient, Love Is Kind and Is Not Jealous; Love Does Not Brag And Is Not Arrogant.

I Corinthians 13:4

The End

Romans 5:8

But God demonstrates His own love toward us, in that while we were yet sinners, Christ died for us.

Final Words

God's Everlasting Love

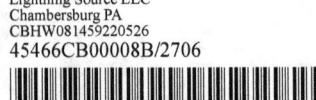

www.ingramcontent.com/pod-product-compliance
Lightning Source LLC
Chambersburg PA
CBHW081459220526
45466CB00008B/2706